BABY NAME:

THANK YOU

FOR PURCHASING THIS MY FIRST EASTER HIGH CONTRAST BABY BOOK

PLEASE DON'T FORGET TO LEAVE US AN HONEST REVIEW AND SHARE WITH US YOUR EXPERIENCE AND HOW CAN HE IMPROVE EVEN MORE.

Made in United States
North Haven, CT
30 March 2023